The mountains are calling and I must go.

—JOHN MUIR

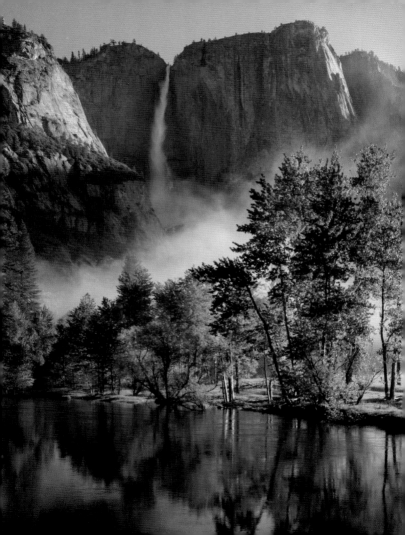

Yosemite Meditations
for Adventurers

PHOTOGRAPHS BY MICHAEL FRYE
EDITED BY CLAUDIA WELSH
FOREWORD BY ROYAL ROBBINS

YOSEMITE CONSERVANCY
YOSEMITE NATIONAL PARK

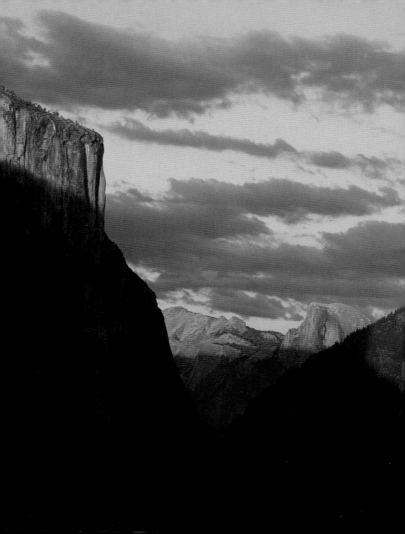

FOREWORD

As someone who has had many adventures in Yosemite, I was pleased to be asked to write this foreword. Yes, Yosemite is quite a place for the adventurous: from scaling the exposed granite walls that surround the Valley, to hiking the many trails that go to the rim, to climbing the domes and peaks of the high country—especially Tuolumne Meadows—Yosemite has the room, space, and terrain to feed any adventurous soul. Of the many inspiring quotes in this little book, my favorites include the words of mountaineers John Muir and Sir Edmund Hillary. And I even have my own: "Before the deed comes the thought. Before the achievement comes the dream. Every mountain we climb we first climb in our mind." When scaling the walls around Yosemite Valley, from El Capitan to Half Dome to Sentinel Rock and Yosemite Point Buttress, from my first ascent of the face of Half Dome to my more recent solo of El Capitan, I have always found it to be true. I hope this book helps awaken your adventurous spirit and inspire your dreams.

ROYAL ROBBINS
MODESTO, CA

Half Dome and El Capitan at end of day

Don't ask yourself
what the world needs.
Ask yourself what makes
you come alive, and go
and do that, because what
the world needs is people
who have come alive.

—HOWARD THURMAN

Vernal Fall with rainbow

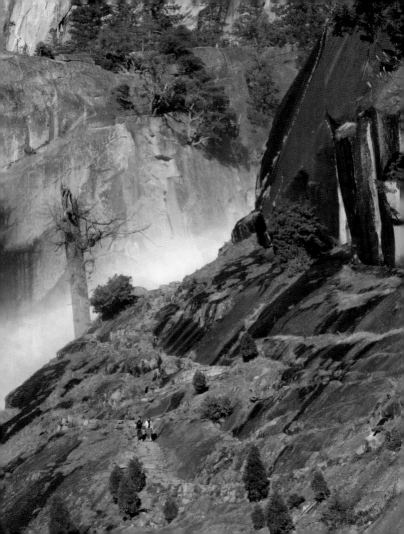

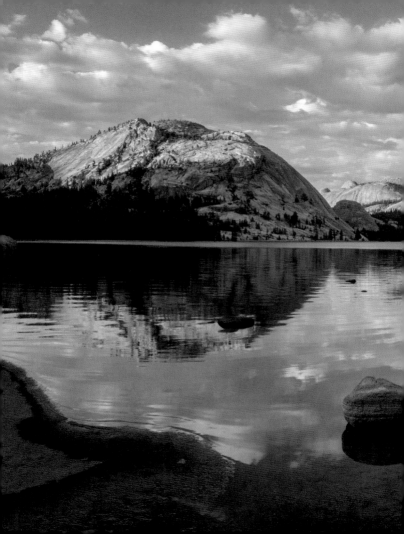

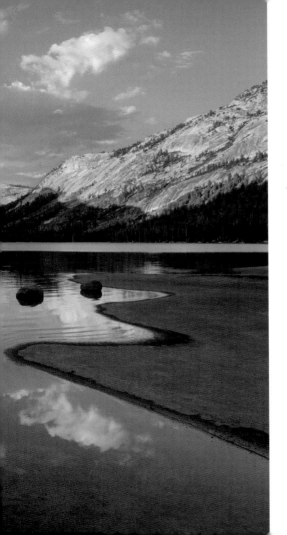

Adventure is not in the guidebook and Beauty is not on the map. Seek and ye shall find.

—RENNY RUSSELL

*Clouds and reflections,
Tenaya Lake*

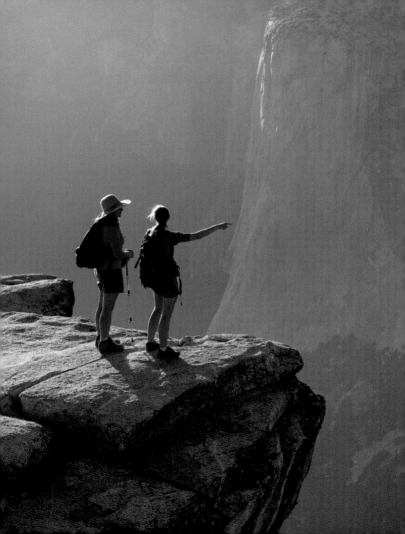

When the pursuit of natural harmony
is a shared journey, great heights can
be attained.

—LYNN HILL

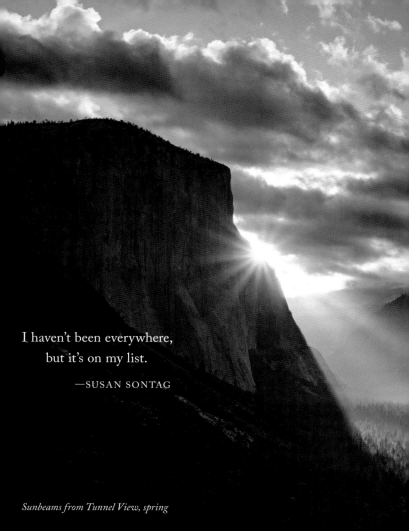

I haven't been everywhere,
but it's on my list.

—SUSAN SONTAG

Sunbeams from Tunnel View, spring

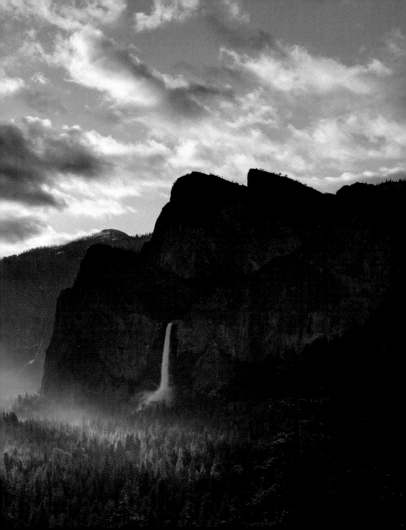

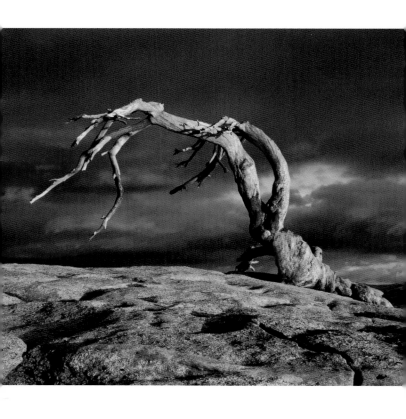

Hiking in the stunning canyons carved
 by the actions of water and ice is a rich,
 rewarding, multilayered experience.
Literally everywhere you turn there is
 something remarkable, something
 utterly breathtaking.

—SHARON GIACOMAZZI

Jeffrey pine at sunset, Sentinel Dome

It is not the mountain we conquer
but ourselves.

—SIR EDMUND HILLARY

Mount Dana at sunset

Following spread: Mule deer grazing on oak leaves

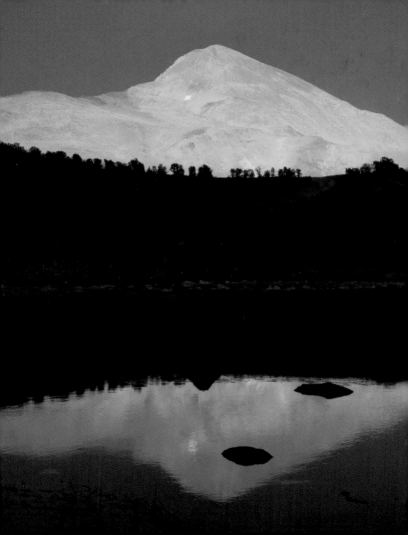

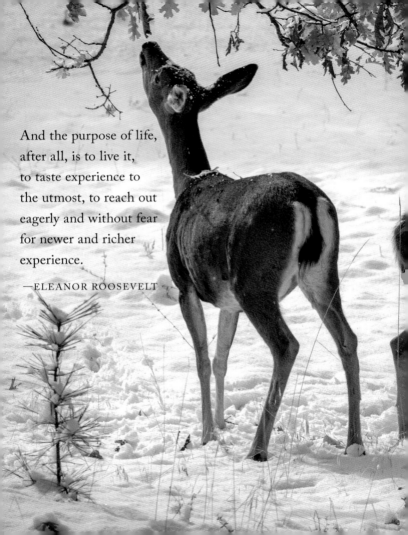

And the purpose of life, after all, is to live it, to taste experience to the utmost, to reach out eagerly and without fear for newer and richer experience.

—ELEANOR ROOSEVELT

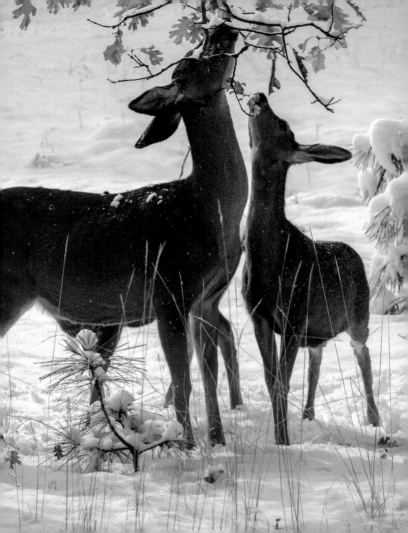

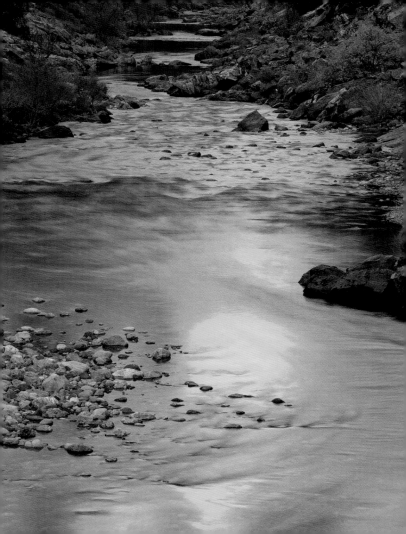

The sun shines not on us but in us.
The rivers flow not past, but through us,
thrilling, tingling, vibrating every fibre
and cell of the substance of our bodies,
making them glide and sing.

—JOHN MUIR

Merced River reflections

Always there is originality and variety
to be found in nature, and nowhere is
it more evident than at high altitudes.

—ENID MICHAEL

North Peak with paintbrush and yellow composites

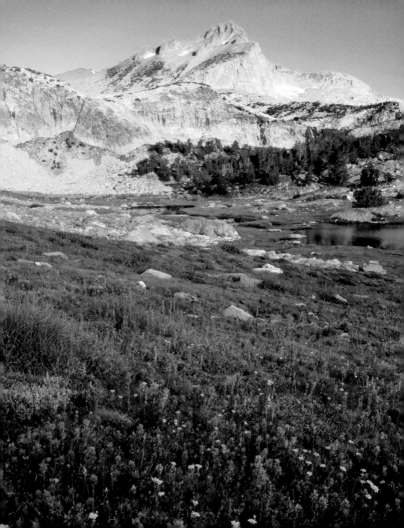

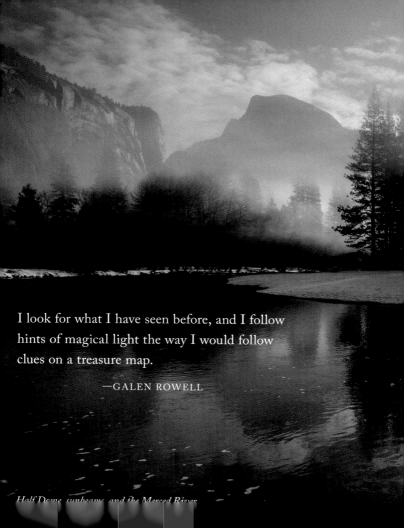

I look for what I have seen before, and I follow
hints of magical light the way I would follow
clues on a treasure map.

—GALEN ROWELL

Half Dome, sunbeams, and the Merced River

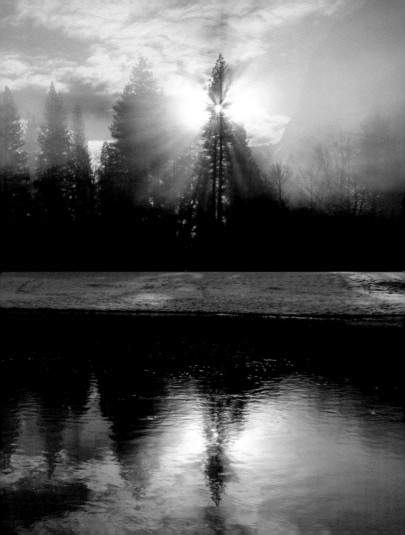

Survey the circling stars,
as though yourself were
in mid-course with them.

—MARCUS AURELIUS

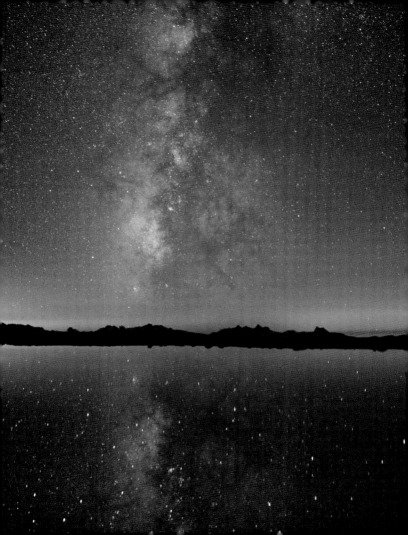

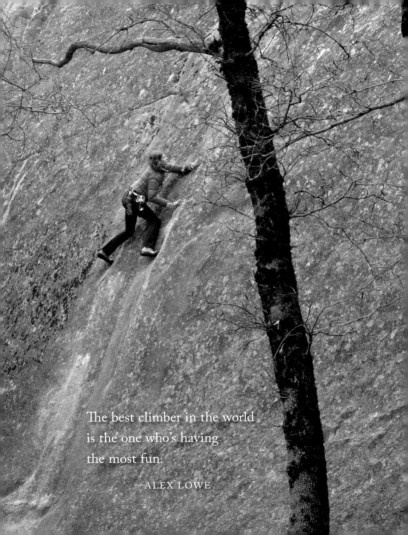

The best climber in the world
is the one who's having
the most fun.

—ALEX LOWE

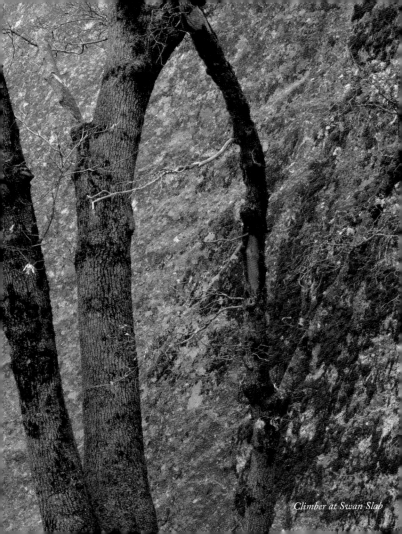

Climber at Swan Slab

To my surprise, I felt a certain springy keenness. I was ready to hike. I had waited months for this day, after all, even if it had been mostly with foreboding. I wanted to see what was out there. . . . I was going for a walk in the woods. I was more than ready for this.

—BILL BRYSON

Dogwood leaves in the sun

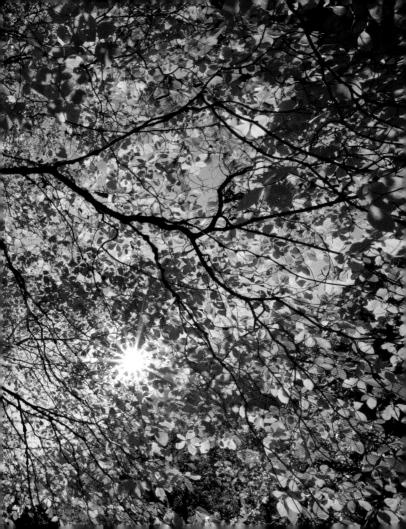

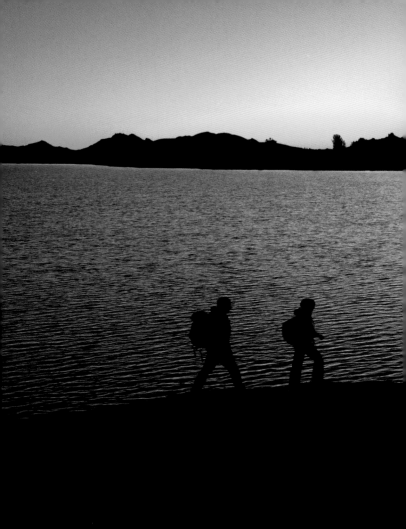

Something to remember: Your feet are like dogs—
they're happiest when they're going somewhere.

—SHARON GIACOMAZZI

Hikers at sunset

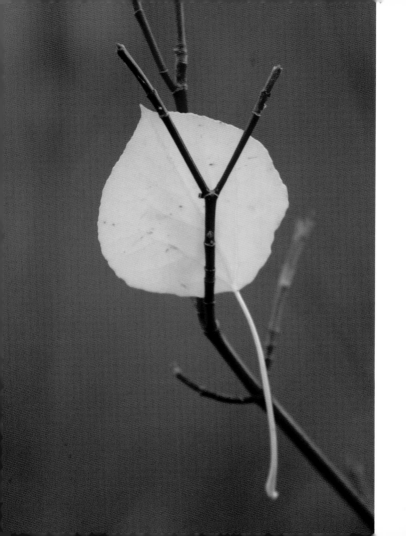

I soon realized that no journey carries one far
unless, as it extends into the world around us,
it goes an equal distance into the world within.

—LILLIAN SMITH

Quaking aspen leaf

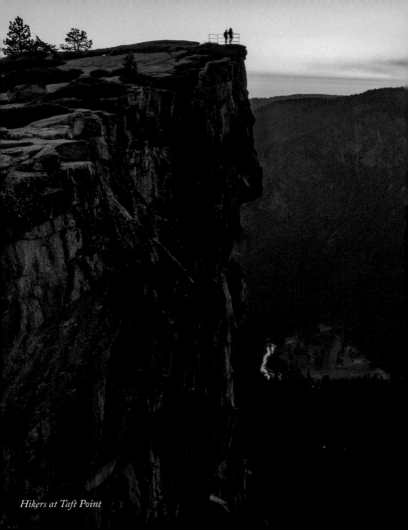

Hikers at Taft Point

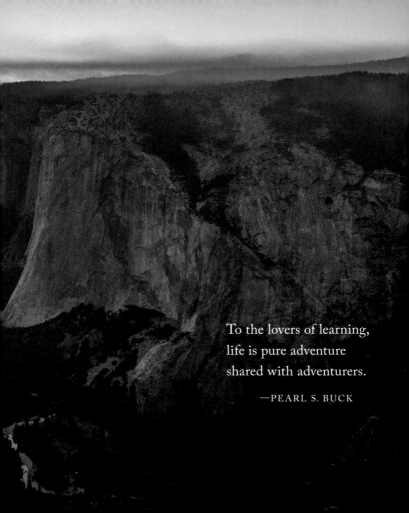

To the lovers of learning,
life is pure adventure
shared with adventurers.

—PEARL S. BUCK

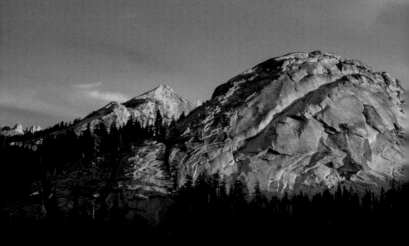

Magic is the only word to describe it,
climbing pitch after pitch of the most perfect,
beautifully sculpted granite in the world.

—RON KAUK

Fairview Dome and clouds

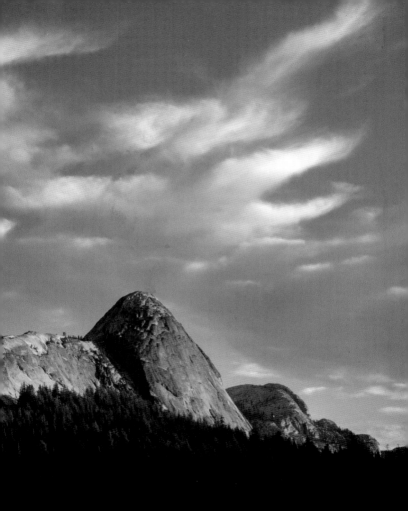

Happiness, knowledge, not in another place
but this place, not for another hour,
but this hour.

—WALT WHITMAN

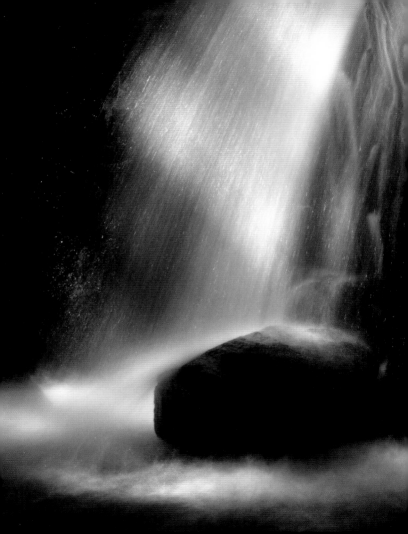

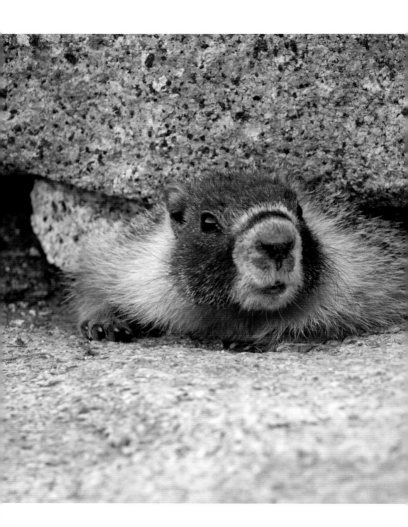

Hiking on any trail, I never know what is waiting around the next bend, yet I feel nature nudging me to put down my agenda and take some risks.

—R. MARK LIEBENOW

Yellow-bellied marmot

I tend to think of the act of photographing,
generally speaking, as an adventure.
My favorite thing is to go where
I've never been.

—DIANE ARBUS

Photographer on Sentinel Dome

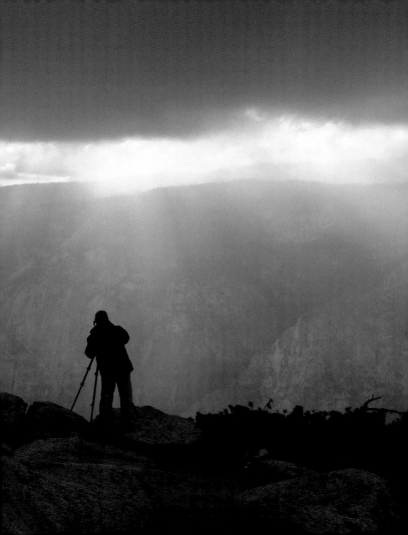

I have need of the sky.

I have business with the grass.

I will up and get me away where the hawk is wheeling,

 Lone and high,

 And the slow clouds go by.

I will get me away to the waters that glass

 The clouds as they pass. . .

I will get me away to the woods.

—RICHARD HOVEY

Sunset clouds, Tenaya Lake

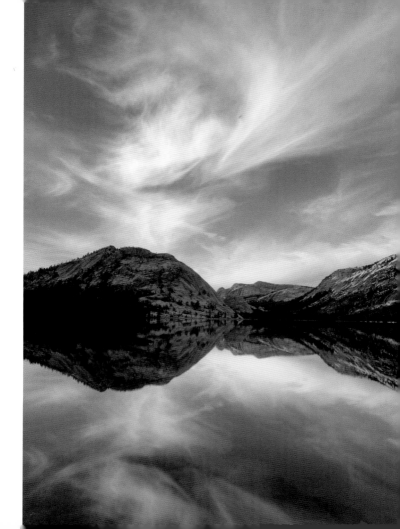

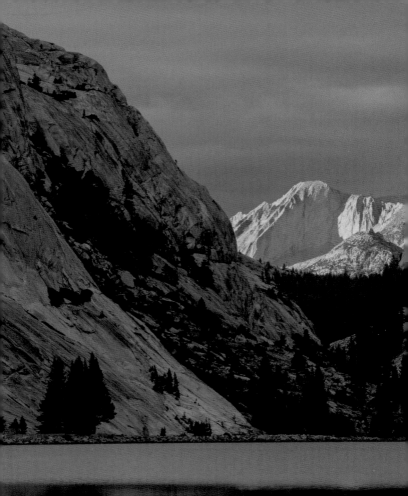

Mount Conness at sunset from Tenaya Lake

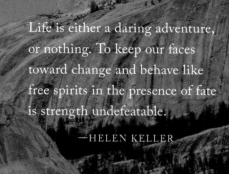

Life is either a daring adventure,
or nothing. To keep our faces
toward change and behave like
free spirits in the presence of fate
is strength undefeatable.

—HELEN KELLER

I was amazed that
what I needed to
survive could be
carried on my back.
And, most surprising
of all, that I could
carry it.

—CHERYL STRAYED

*Backpackers heading out
on the trail*

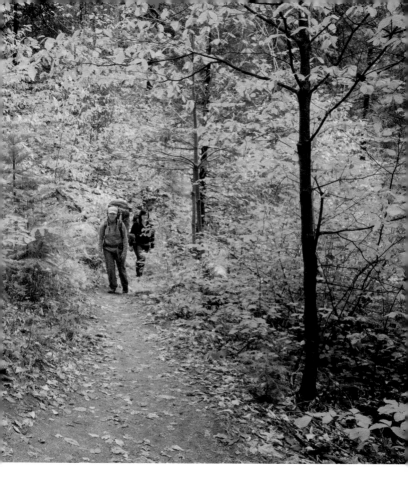

For me an adventure is something that I can take an active part in but that I don't have total control over.

—PETER CROFT

Sunbeams on El Capitan reflected in the Merced River

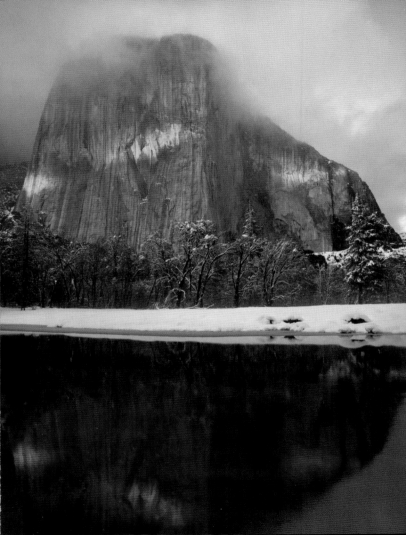

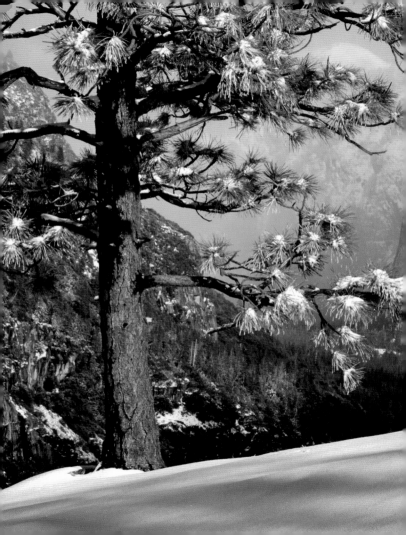

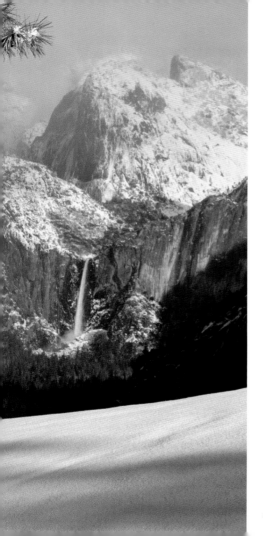

Adventure is a path. Real adventure—self-determined, self-motivated, often risky—forces you to have firsthand encounters with the world. The world the way it is, not the way you imagine it.

—MARK JENKINS

Bridalveil Fall and Jeffrey pine, winter

I believe that each of us embraces a last, best place in our hearts—a part of the world that resonates with our energy, that creates a bond with nature and nurtures and restores our souls. When we find our spiritual home, we know instantly it is where we belong.

—SHARON GIACOMAZZI

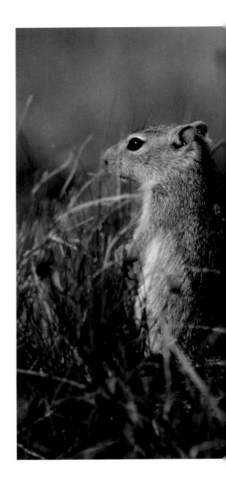

Young Belding's ground squirrels, Tuolumne Meadows

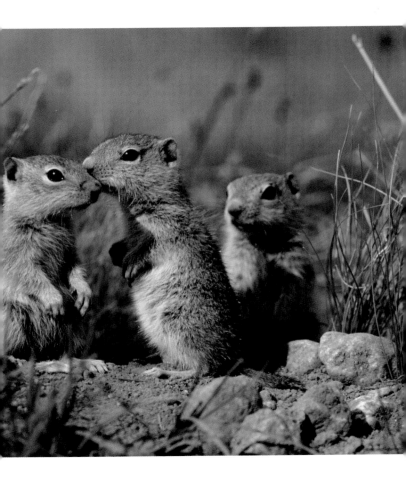

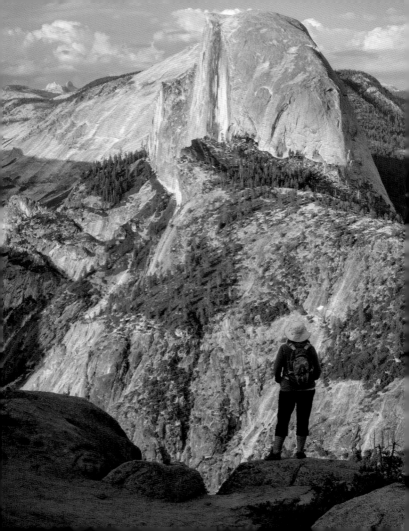

Only those who will risk
going too far can possibly
find out just how far
one can go!

—T. S. ELIOT

The sunshine fell warm on the crag, and there was silence except for the faint, far away sound of falling water, the distant call of the Clark crow and occasionally, the murmur of the wind about the hollow flanks of the peak.

—NORMAN CLYDE

Unicorn Peak reflected in pond, Tuolumne Meadows

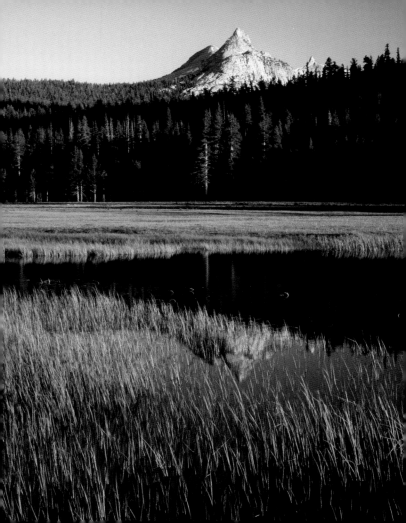

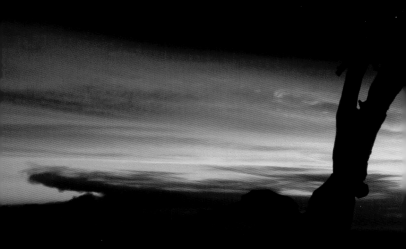

All the wide world is beautiful,
 and it matters but little where we go. . . .
The spot where we chance to be
 always seems the best.

—JOHN MUIR

Sunset from the top of Sentinel Dome

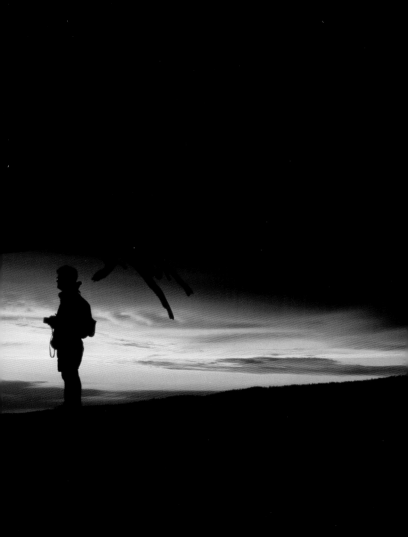

If life is movement, then rock—
 with its atoms flying around
like stars in the cosmos—
 is alive.

—YVON CHOUINARD

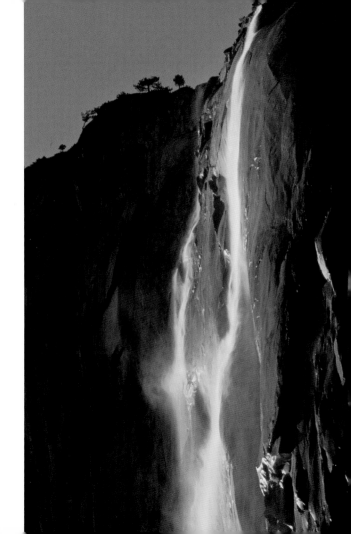

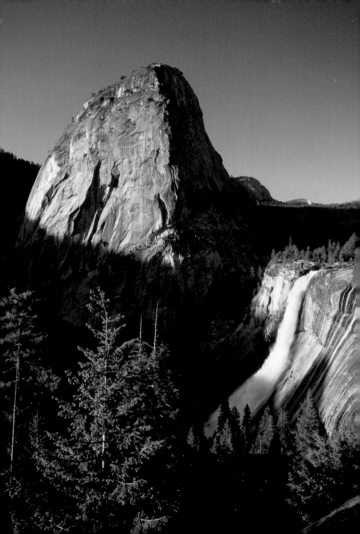

Should you be hesitant to get your boots on rather vertical trails, it's time to adjust your thinking.

—SHARON GIACOMAZZI

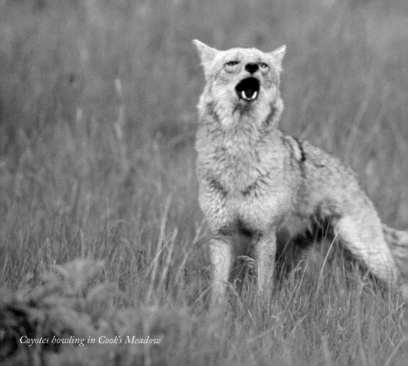

To be whole. To be complete. Wildness reminds us what it means to be human, what we are connected to rather than what we are separate from.

—TERRY TEMPEST WILLIAMS

Coyotes howling in Cook's Meadow

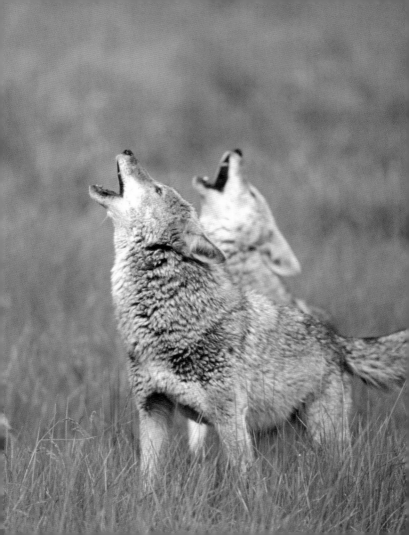

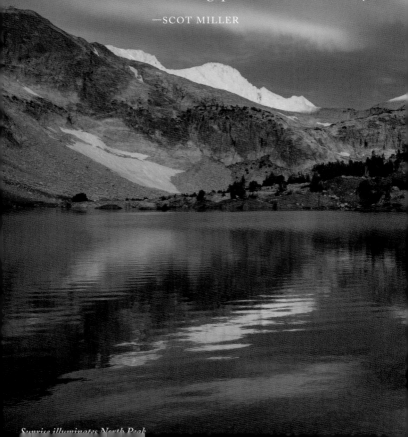

In parts of Yosemite . . . , you can hike for days and see few, if any, other people, all the while taking in mile after mile of breathtaking, pristine mountain scenery.

—SCOT MILLER

Sunrise illuminates North Peak

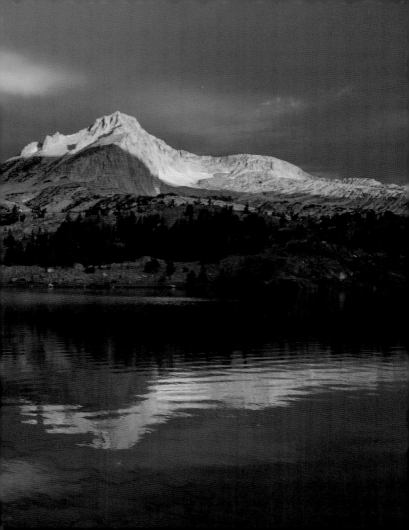

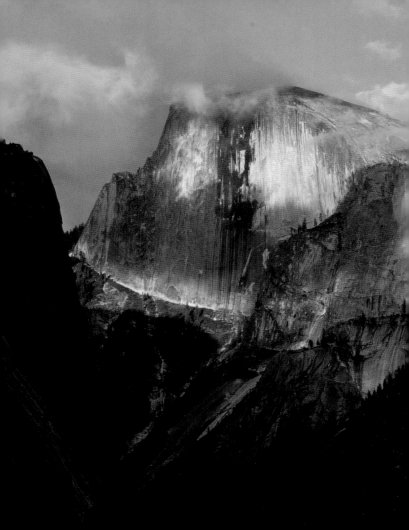

May your trails be crooked,
 winding, lonesome, dangerous,
 leading to the most amazing view.
May your mountains rise into
 and above the clouds.

— EDWARD ABBEY

Half Dome and clouds

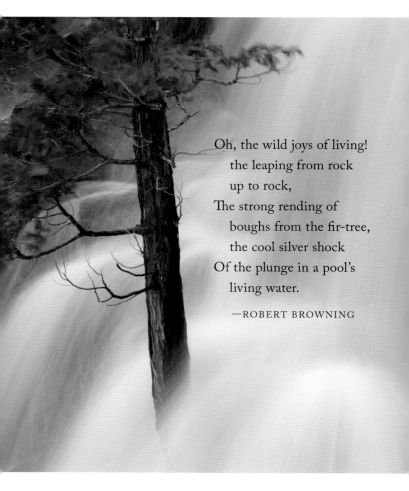

Oh, the wild joys of living!
 the leaping from rock
 up to rock,
The strong rending of
 boughs from the fir-tree,
 the cool silver shock
Of the plunge in a pool's
 living water.

—ROBERT BROWNING

Incense cedar and Cascade Creek

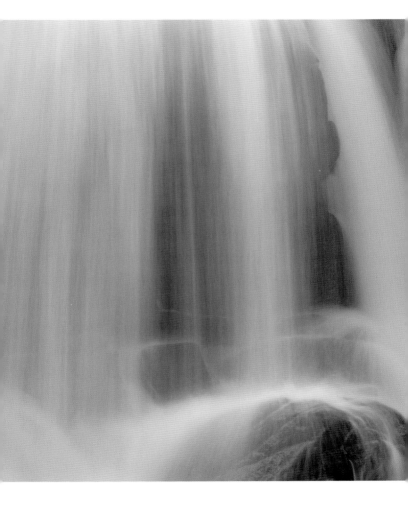

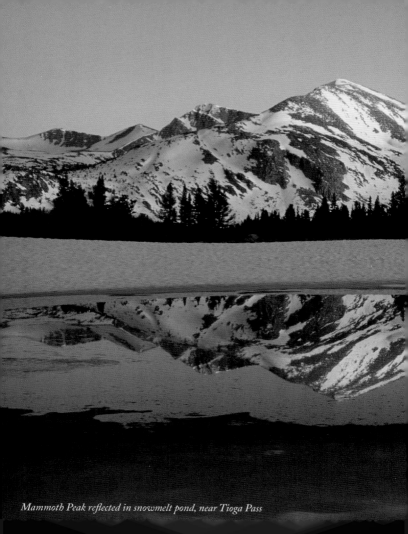

Mammoth Peak reflected in snowmelt pond, near Tioga Pass

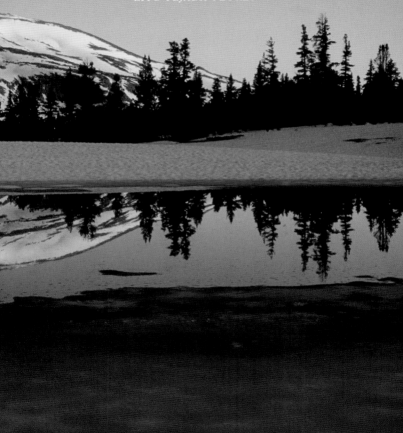

You never climb the same mountain twice, not even in memory. Memory rebuilds the mountain, changes the weather, retells the jokes, remakes all the moves.

—LITO TEJADA-FLORES

Love the moment
and the energy of that
moment will spread
beyond all boundaries.

—CORITA KENT

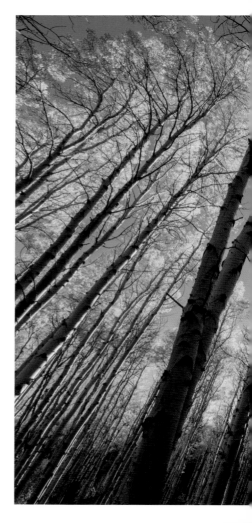

Aspen grove, late afternoon,
Lee Vining Canyon

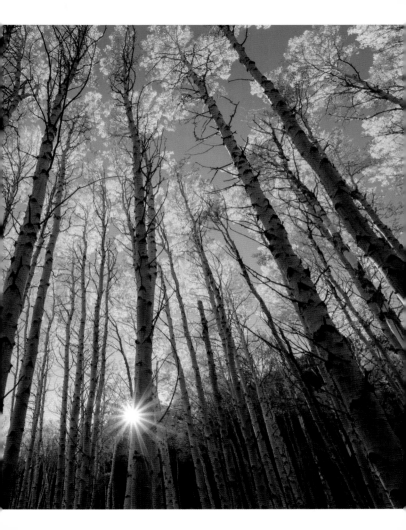

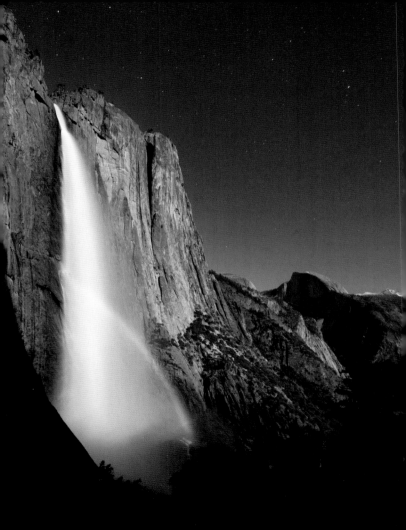

People say that what we're all seeking is a meaning for life. I don't think that's what we're really seeking. I think that what we're seeking is an experience of being alive.

—JOSEPH CAMPBELL

Half Dome and Upper Yosemite Fall with a lunar rainbow

Chance is always powerful. Let your hook be always cast; in the pool where you least expect it, there will be a fish.

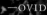

—OVID

Boy playing along Yosemite Creek

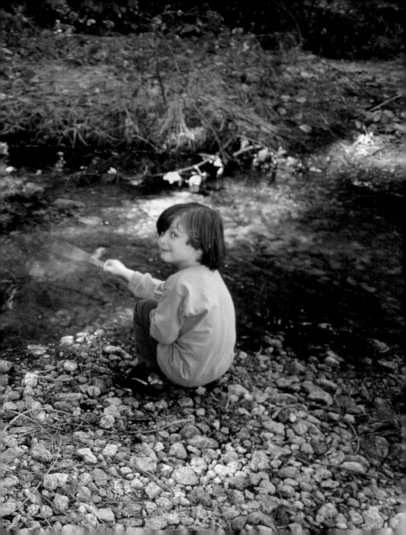

No more greater joy can come from life
than to live inside a moment of adventure.
It is the uncommon wilderness experience
that gives your life expectation.

—FROSTY WOOLDRIDGE

Three Brothers reflected in the Merced River on a moonlit night

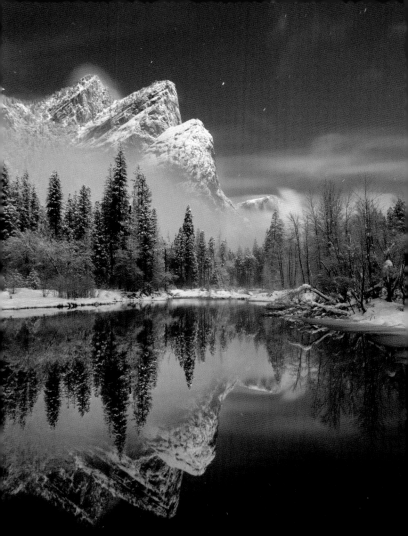

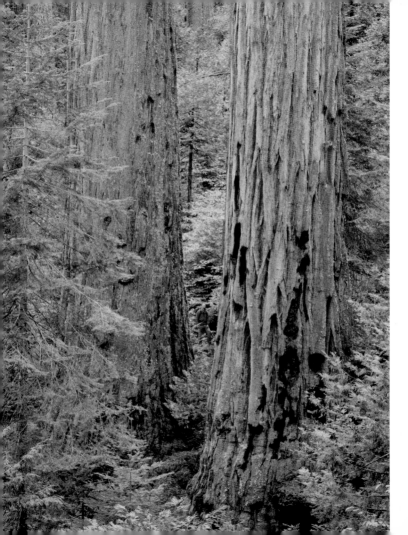

Nobody can discover the world for anybody
else. It is only when we have discovered
it for ourselves that it becomes a common
ground and a common bond, and we cease
to be alone.

—WENDELL BERRY

Hiker and giant sequoias

We had left no mark on the country itself,
but the land had left its mark on us. . . .

—SIGURD F. OLSON

Hiker taking in a high-country view

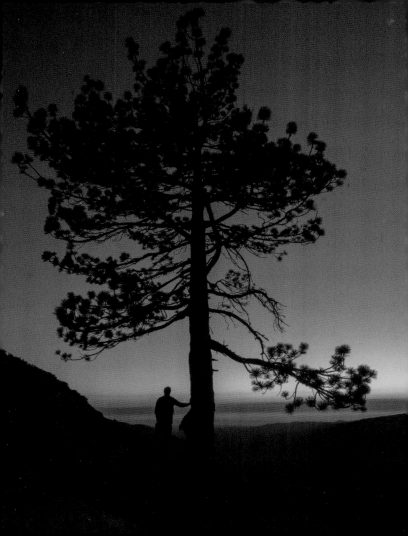

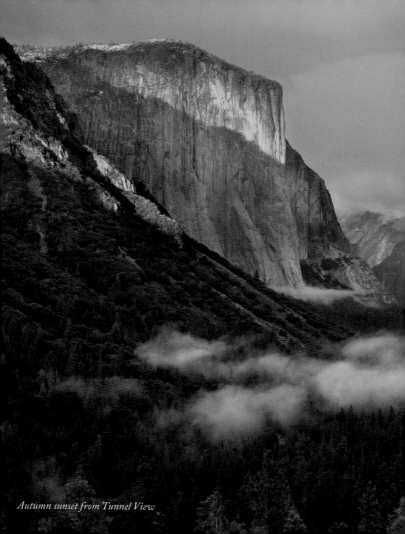
Autumn sunset from Tunnel View

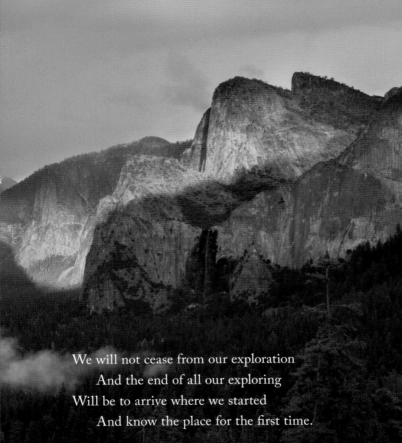

We will not cease from our exploration
 And the end of all our exploring
Will be to arrive where we started
 And know the place for the first time.

—T. S. ELIOT

Wherever you go,
go with all your heart.

—CONFUCIUS

SOURCES

Abbey, Edward, *Desert Solitaire*. Tuscon, AZ: The University of Arizona Press, 1988. Used with permission.

Arbus, Diane, quoted in "Arbus Speaks," by Hilton Als. *The New Yorker*, September 28, 2011. Used with permission.

Aurelius, Marcus, *Meditations*. Harmondsworth, England: Penguin Books Ltd, 1964.

Berry, Wendell, *The Unforeseen Wilderness: Kentucky's Red River Gorge*. New York: North Point Press, 1991. Used with permission.

Browning, Robert, "Saul." *Poems of Robert Browning*. New York: Thomas Y. Crowell & Company, 1889.

Bryson, Bill, *A Walk in the Woods*. New York: Broadway Books/Random House, 1998. Used with permission.

Buck, Pearl S., "The Delights of Learning." *Address Delivered on the Occasion of the University of Pittsburg Honors Convocation, April 6, 1960*. Pittsburg, PA: University of Pittsburg Press, 1960. Used with permission.

Campbell, Joseph, *The Power of Myth*. New York: Anchor Books/Random House, 1988. Used with permission.

Chouinard, Yvon, Foreword to *Spirit of the Rock* by Ron Kauk. Layton, UT: Gibbs Smith, 2003. Used with permission.

Clyde, Norman, *Close Ups of the High Sierra*. Bishop, CA: Spotted Dog Press, 1997. Used with permission.

Confucius, as quoted in *Wilderness Wisdom* by the National Outdoor Leadership School. Mechanicsburg, PA: Stackpole Books, 2012.

Croft, Peter, as quoted in "Quote of the Week," from www.ClimbandMore .com, August 28, 2006.

Eliot, T. S., as quoted in the Preface to *Transit of Venus* by Harry Crosby. Paris: Black Sun Press, 1931.

Giacomazzi, Sharon, *Exploring Eastern Sierra Canyons: Sonora Pass to Pine Creek*. Mendocino, CA: Bored Feet Press, 2006. Used with permission. *Hiking in the stunning canyons ...*

Ibid. *Something to remember . . .*

Ibid. *I believe that each of us embraces . . .*

Ibid. *Should you be hesitant . . .*

Hill, Lynn, as quoted in *The Quotable Climber,* edited by Jonathan Waterman. Guilford, CT: The Globe Pequot Press, 2002. Used with permission.

Hillary, Sir Edmund, as quoted in "About Hillary," from www.siredmund hillary.com. Used with permission.

Hovey, Richard, "Spring." *Some Modern Verse.* Springfield, MA: Springfield City Library Association, 1908.

Jenkins, Mark, "The Ghost Road." *Outside Magazine,* October 2003. Used with permission.

Kauk, Ron, *Spirit of the Rock.* Layton, UT: Gibbs Smith, 2003. Used with permission.

Keller, Helen, *Let Us Have Faith,* 1st ed. New York: Doubleday, Doran, 1940. Used with permission.

Kent, Corita, from *love the moment,* serigraph 77–01 by the artist Corita (Sister Mary Corita Kent). Reproduction permission of the Corita Art Center, Immaculate Heart Community, Los Angeles.

Liebenow, R. Mark, *Mountains of Light.* Lincoln, NE: University of Nebraska Press, 2012. Used with permission.

Lowe, Alex, as quoted in *Forget Me Not* by Jennifer Lowe-Anker. Seattle, WA: The Mountaineers Books, 2008. Used with permission.

Michael, Enid, *The Joy of Yosemite: Selected Writings of Enid Michael, Pioneer Ranger Naturalist.* Rancho Palos Verdes, CA: Quaking Aspen Books, 2004. Used with permission.

Miller, Scot, *First Light: Five Photographers Explore Yosemite's Wilderness.* Berkeley, CA: Heyday/Yosemite Association, 2009. Used with permission.

Muir, John, as quoted in *The Life and Letters of John Muir* by William Frederic Badè. Boston: Houghton Mifflin, 1924. *The mountains are calling . . .*

Muir, John, as quoted in *Sacred Summits: John Muir's Greatest Climbs,* edited by Graham White. Edinburgh: Canongate Books Ltd, 1999. *The sun shines not on us but in us. . . .*

Muir, John, as quoted in *John Muir: In his Own Words,* edited by Peter Browning. Lafayette, CA: Great West Books, 1988. *All the wide world is beautiful. . . .*

Olsen, Sigurd, *Wilderness Days*. Minneapolis: University of Minnesota Press, 2012. Used with permission.

Ovid, *Heroides*. London: Penguin Group, 1990.

Roosevelt, Eleanor, *You Learn by Living: Eleven Keys for a More Fulfilling Life*. Louisville, KY: Westminster John Knox Press, 1960. Used with permission.

Rowell, Galen, as quoted in *Galen Rowell's Sierra Nevada*, compiled by the Editors of Sierra Club Books. San Francisco: Sierra Club, 2010. Used with permission.

Russell, Renny, *On the Loose* by Jerry and Renny Russell. San Francisco: Sierra Club, 1967. Used with permission.

Smith, Lillian, as quoted in *A Journey Around America: A Memoir on Cycling, Immigration, and the Latinoization of the U. S.* by Louis G. Mendoza. Austin, TX: University of Texas Press, 2012. Used with permission.

Sontag, Susan, *I, etcetera*. New York: Doubleday, 1978. Used with permission.

Strayed, Cheryl. *Wild: From Lost to Found on the Pacific Crest Trail*. New York: Alfred A. Knopf, 2012. Used with permission.

Tejada-Flores, Lito, "1968, The Way It Wasn't." *Alpinist Magazine*, issue no. 5 (Winter 2003–2004). Used with permission.

Thurman, Howard, as quoted in *Violence Unveiled: Humanity at the Crossroads* by Gil Baile. New York: The Crossroads Publishing Company, 1995. Used with permission.

Whitman, Walt. *The Complete Poems of Walt Whitman*. Hertfordshire, England: Wordsworth Editions Limited, 1995.

Williams, Terry Tempest, excerpt from "Statement Before the Senate Subcommittee on Forest & Public Lands Management Regarding the Utah Public Lands Management Act of 1995, Washington, DC July 13 1995." Copyright © 1995 by Terry Tempest Williams. Also in *Red: Patience and Passion in the Desert*. New York: Vintage/Random House, 2002. Used by permission of Brandt and Hochman Literary Agents, Inc.

Wooldridge, Frosty, *How to Live a Life of Adventure: The Art of Exploring the World*. Bloomington, IN: AuthorHouse, 2011. Used with permission.

To all of Yosemite's adventurers, who have inspired us
to explore every beautiful corner of this park—
and to everyone with an adventurous spirit.
—MF & CW

Yosemite Conservancy's Mission
Providing for Yosemite's future is our
passion. We inspire people to support
projects and programs that preserve
and protect Yosemite National Park's
resources and enrich the visitor
experience.

Library of Congress Control
Number: 2013957503

Cover photograph by Michael Frye
Design by Nancy Austin

ISBN 978-1-930238-46-6

Printed in China by Everbest Print-
ing Co. through Four Colour Imports
Ltd., Louisville, Kentucky

1 2 3 4 5 6 – 18 17 16 15 14

YOSEMITE
CONSERVANCY.

yosemiteconservancy.org

MIX
Paper
FSC FSC™ C005413